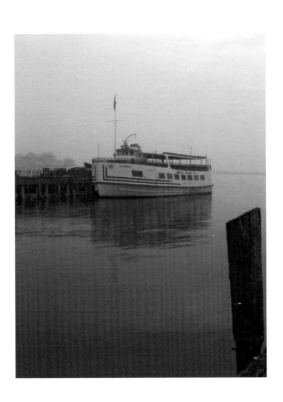

Mackinac Island

photography by **Terry W. Phipps**

The University of Michigan Press
and
Petoskey Publishing

For
Leonard V. Trankina

Published in the United States of America by
The University of Michigan Press
and
The Petoskey Publishing Company

Manufactured in Canada
20011 2010 2009 2008 5 4 3 2 1
ISBN-10: 0-472-11681-9
ISBN-13: 978-0-472-11681-2
Library of Congress Cataloging-in-Publication Data on File

Signed Limited Edition Prints
t.phipps@greatlakestraveler.com

Other titles include:
Seasons of Sleeping Bear, Seasons of Mackinac, Seasons of Little Traverse
Sleeping Bear Dunes National Lakeshore, and *Mackinac Island*

Preface

Day tripping works for many, but the only true experience comes with staying awhile. Only then do the nuances trickle into your senses. The little Tourism Bureau booth, directly across the street from the Arnold docks, can direct divergent discoveries or solve most any travel dilemma. For instance, how many have really seen the Crack in the Island, the Cave in the Woods, or the Lime Kiln? Few have walked the Wildflower Nature Trail, the Tranquil Bluff, Manitou trails, or fifty-three of the other trails. Aside from the city niches left uncovered, the State Park offers solace for resurrecting the Thoreau in us all. "I find it wholesome to be alone the greater part of the time. To be in company, even with the best, is soon wearisome and dissipating. I love to be alone. I never found the companion that was so companionable as solitude."

The Mackinac Island State Park Visitor's Center, next to the marina, is a good place to start. Most of the historic buildings are open through mid-October. While numerous buildings are within Fort Mackinac's walls, others string along Market Street. The Beaumont Memorial, the Stuart House, the Biddle House, the American Fur Company Warehouse, and the Benjamin Blacksmith shop are must sees on Market Street. Fort Mackinac is a colonial history lesson, as are Fort Holms in the interior, and the British Landing across the island.

Historically, the Chippewa occupied the region since the 1600s. Jean Nicolet was the first European to see Mishi-minauk-in-ong. The Black Robes soon followed. Fur traders, soldiers from three nations, and fishermen. The tourism demand eventually brought the first steamship, *Walk-in-the Water* (June 1819). The Grand Hotel's construction (1887) set the standards that established this island Mecca for the wealthy. Since the dawn of the resort era, the island has grown into the number two tourist destination in the Midwest.

Declared as the second National Park by Congress in 1876, the park transferred hands to the state of Michigan. The park currently owns a whopping eighty-one percent of the island. The twenty-two-hundred-acre island obscures its treasures to most visitors. Interestingly, its main highway, M-185, is the only highway never to have had an auto accident. Automobiles were banned 1898 when the first one frightened a horse. Although the island's downtown is filled with many visual delights and attractions, the greatest asset is the peace of the late-night taxi clip-clopping through empty streets, the early morning coffee shops, and the near silence of the waves rippling into shore.

Terry W. Phipps

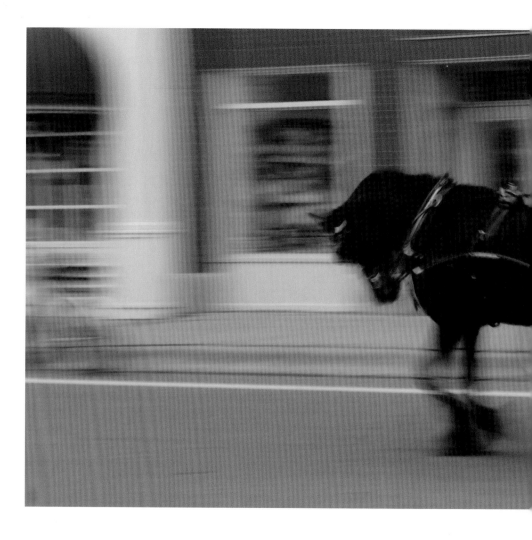

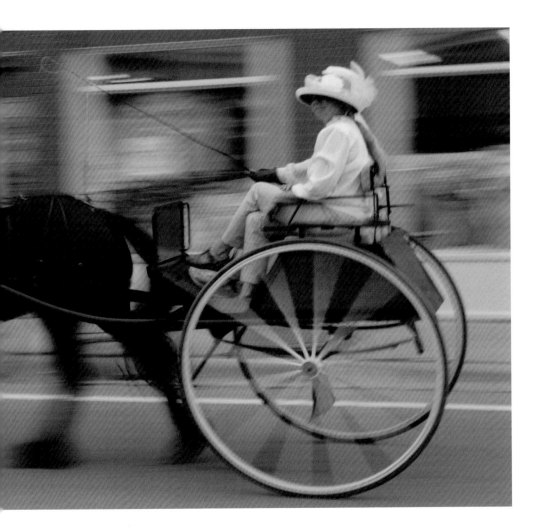

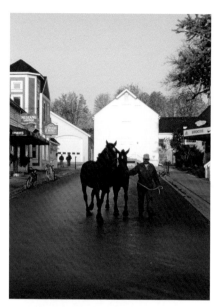

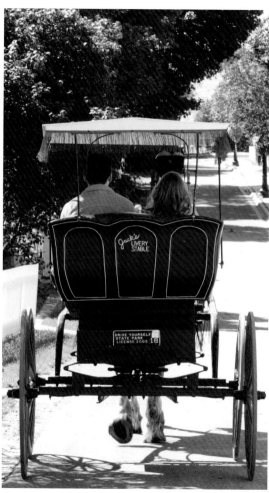

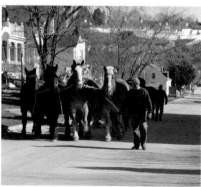

Horses leaving the island in fall and returning in the spring, and a buggy ride

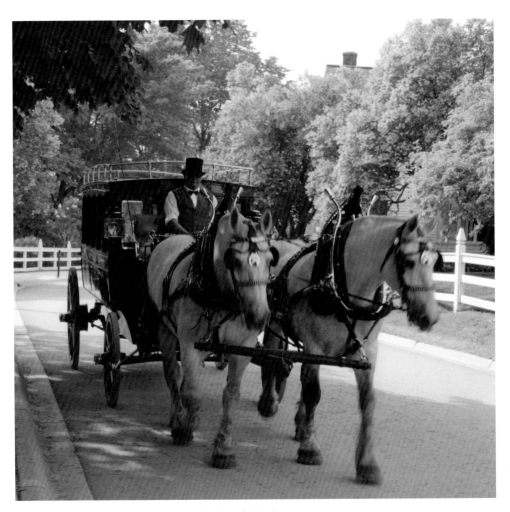

The Grand Hotel carriage

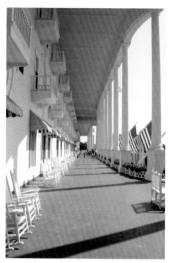

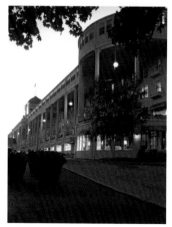

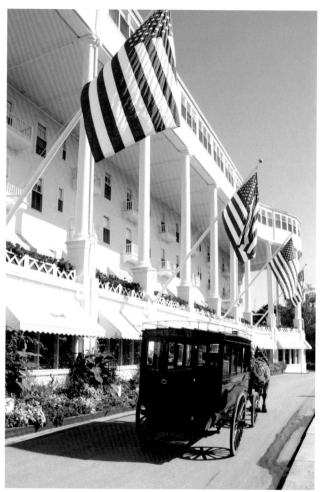

The Grand Hotel

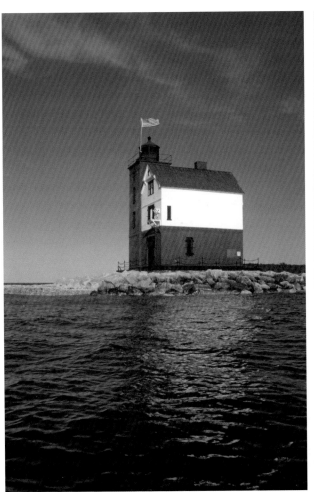
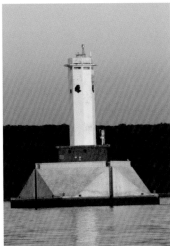
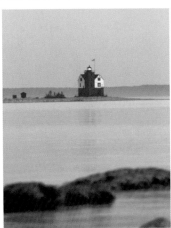

Round Island Light (left and bottom right), the Harbor Light (top right)

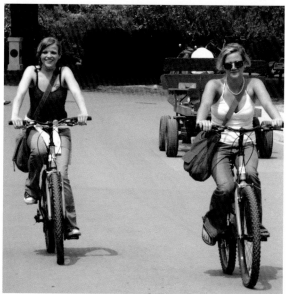

Island biking

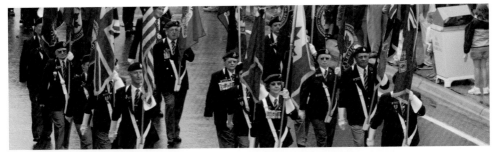

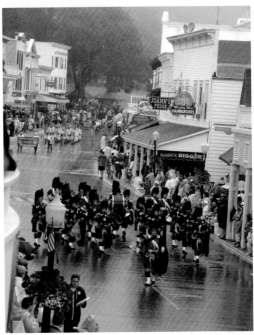

The Lilac Festival

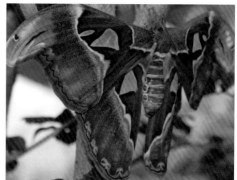

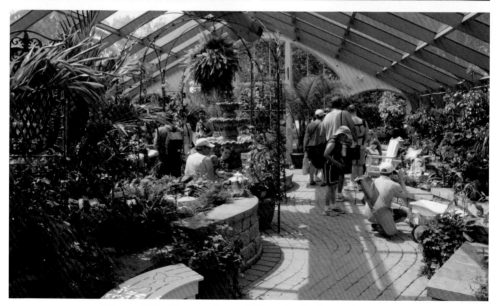

Wings of Mackinac at Surrey Hill and at the Butterfly House

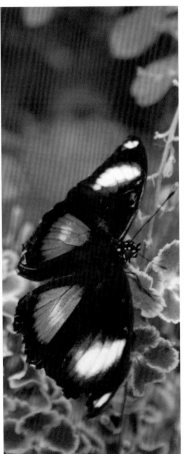

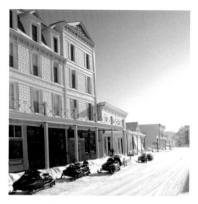

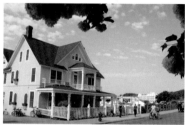

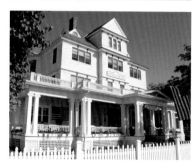

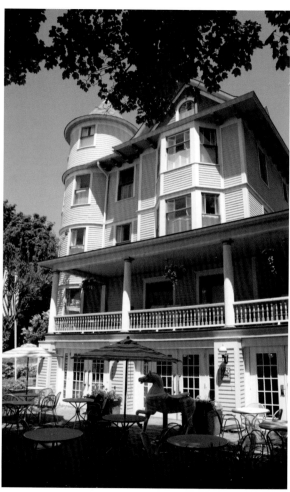

The Chippewa Hotel, the Windemere, the Bayview, and the Inn on Mackinac

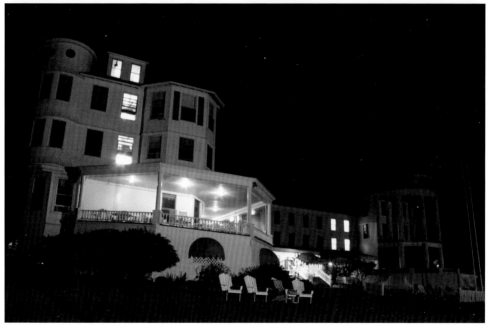

The Island House

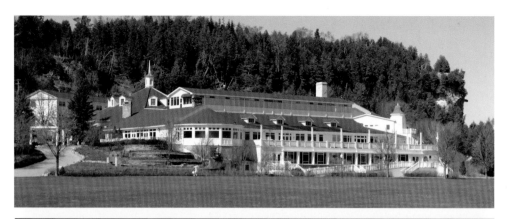

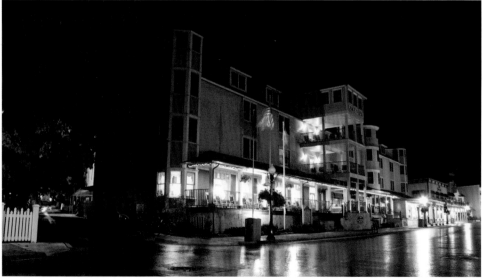

Mission Point, the Lakeview Hotel

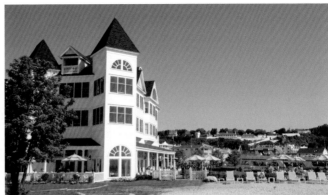
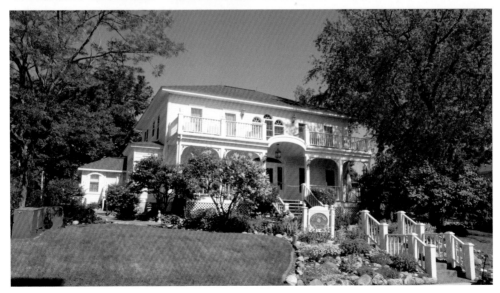

Hotel Iroquois and Clogbaun (top right)

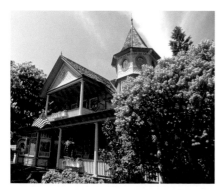

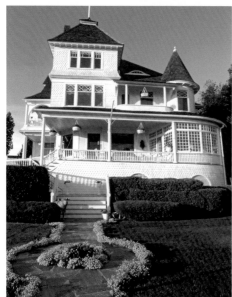
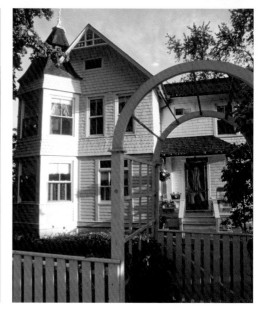

Victorian homes

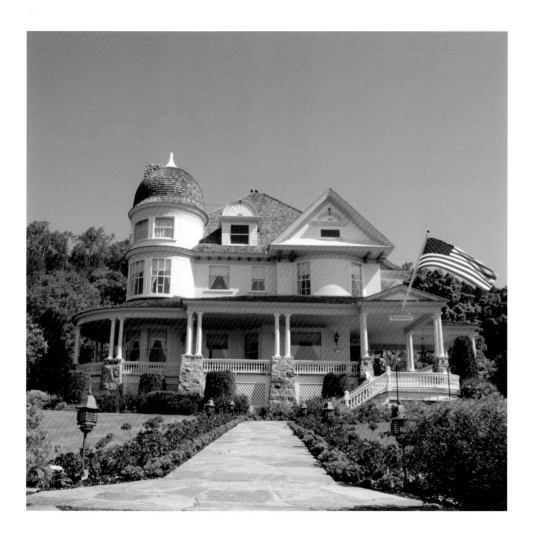

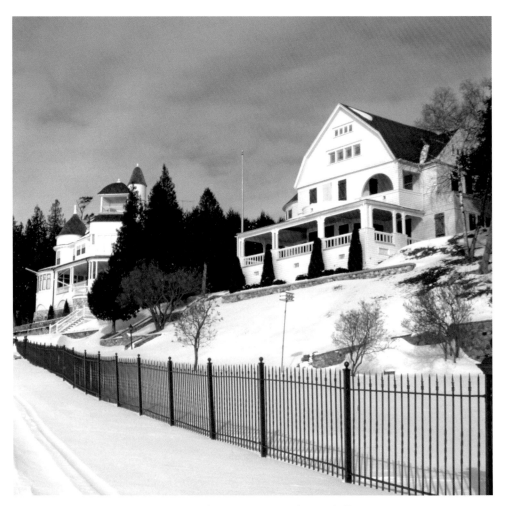

Victorian homes on West and East Bluff

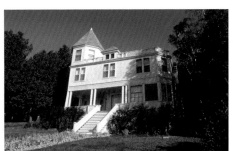
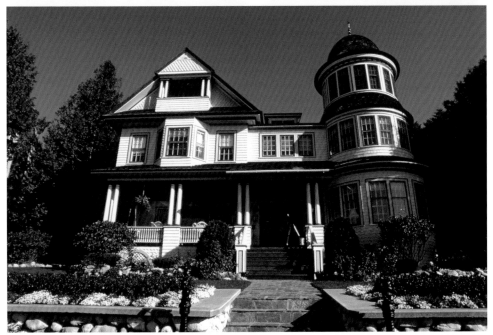

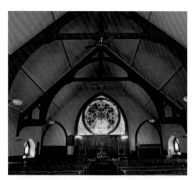

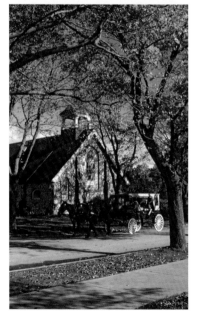

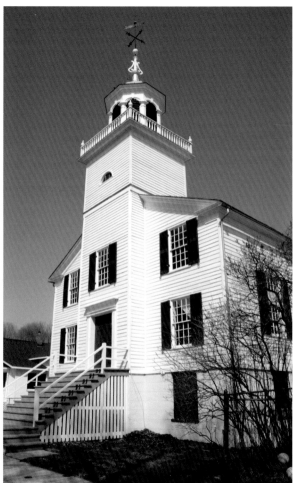

The Little Stone Church, the Mission Church

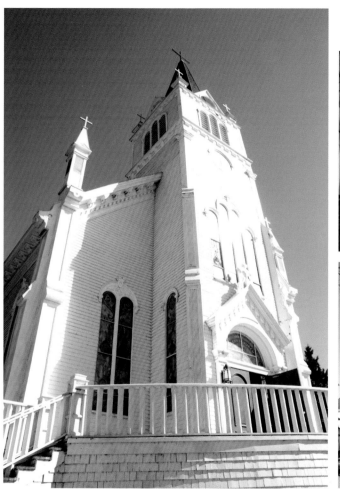
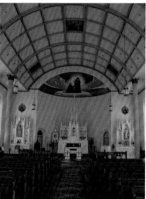
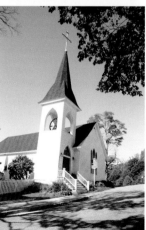

St. Anne's and Trinity Church

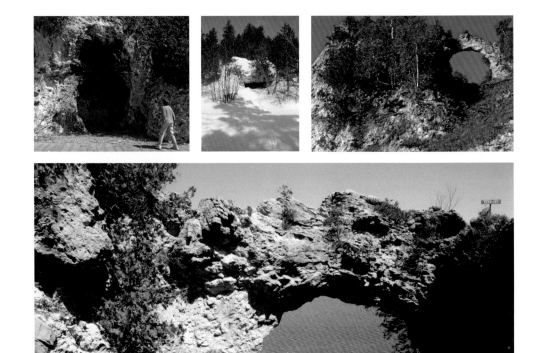

Devils Kitchen, Skull Cave, Arch Rock

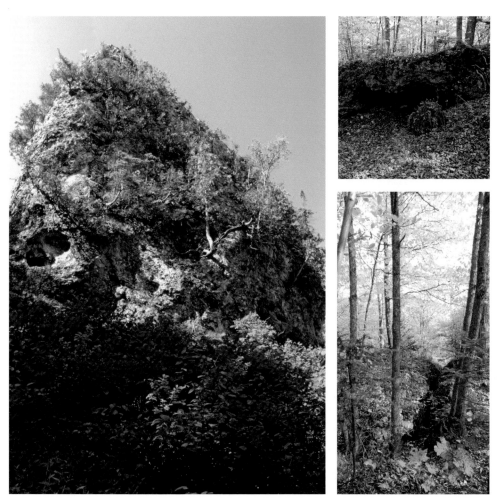

Surgarloaf, Cave in the Woods, the Crack in the Island

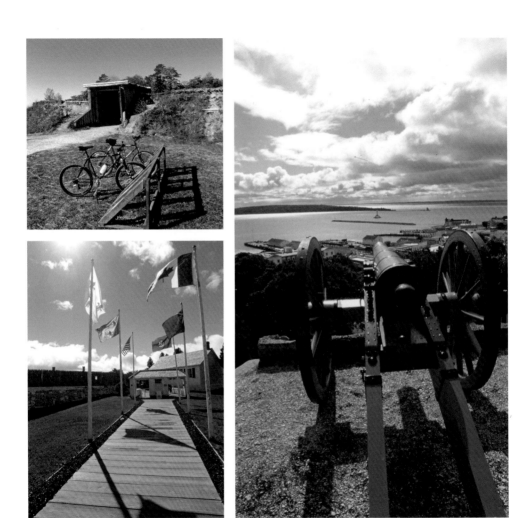

Ft. Holms (top left)

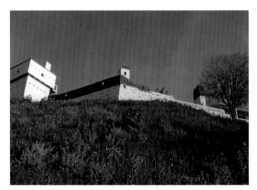

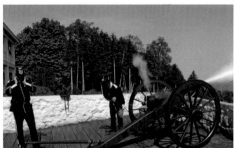

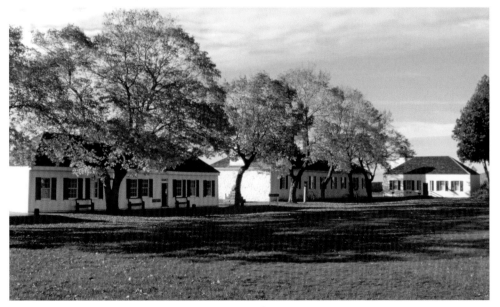

Fort Mackinac

Haldimand Bay

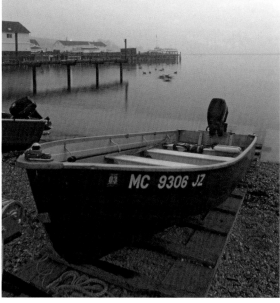

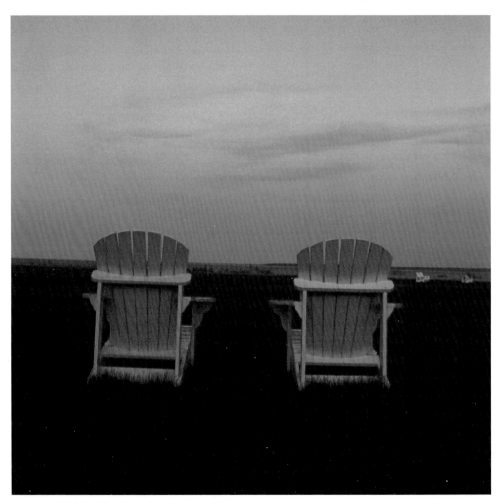

Mission Point